Remembering Miss O'Keeffe

Stories from Abiquiu

By Margaret Wood
Photographs by Myron Wood

MUSEUM OF NEW MEXICO PRESS
SANTA FE

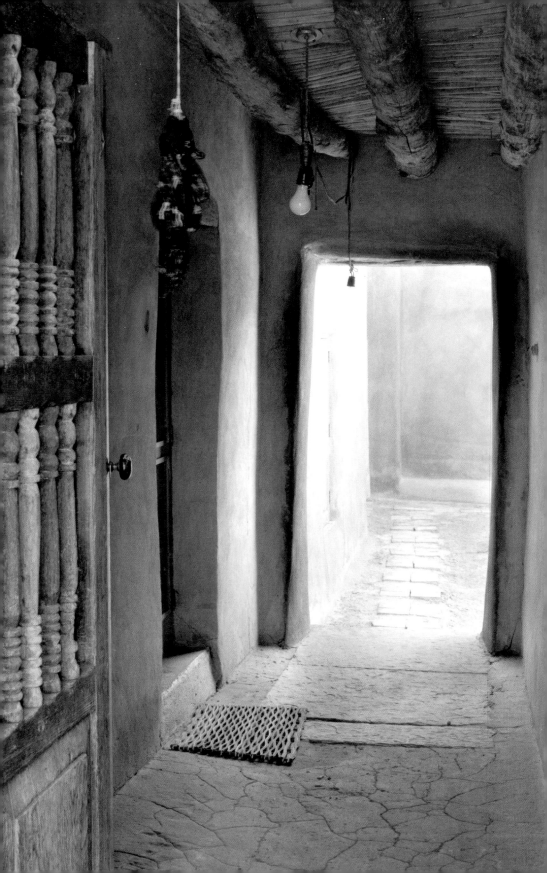

Contents

7 · Foreword by Miriam Sagan

11 · Weaving a New Life

17 · The Garden and the Watercress Stream

25 · Evening Rhythms

31 · Through High Adobe Walls

39 · Tales from the Past

45 · The Blank Canvas

51 · Land of Red hills

57 · The Roofless Room

63 · A Note on the Photographs

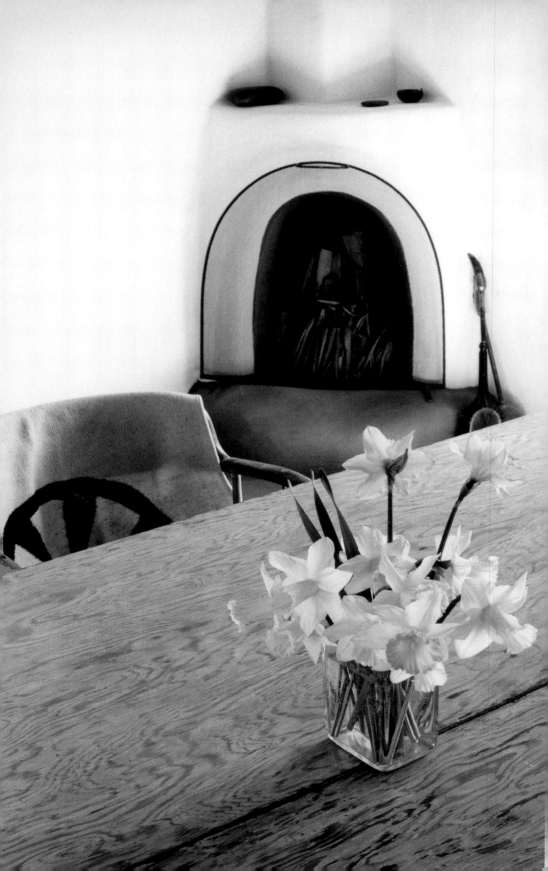

FOREWORD

Miriam Sagan

Ayoung woman just finding her way in the world becomes caretaker to an older woman artist. As much apprentice as companion, the young woman struggles with the demands and needs of the older. Gradually the relationship transforms. The helper is helped, the older woman learns from the younger, until the flow of life and death separate them. But not before the younger woman has discovered a great deal about the world and herself.

A fairytale? This memoir by Margaret Wood of being a companion to Georgia O'Keeffe certainly has a mythic structure, but it is a story firmly set in this world. A quest for watercress and a scene in which the painter guides another's hand are indeed worthy of a heroine's journey. But memory also firmly roots this reminiscence in the everyday—cooking, gardening, walking, conversation.

When Margaret Wood came to work for the elderly O'Keeffe in 1977, it was with a kind of youthful innocence. O'Keeffe was the established icon—and an exacting employer—but Wood experienced this world freshly, without much preconception or self-consciousness. At times a Cinderella, endlessly scrubbing cork tile; at times a Sheherazade—soothing with a tale—she experienced what was happening to her directly, without fixed ideas about the famous artist or her own situation.

As a result, this memoir is unique and vital. And because it would be some twenty-four years before Wood would write down what she experienced, time and understanding have added patina to the experience.

As valuable as a book of reminiscences of Georgia O'Keeffe would be, this memoir offers more. The world remains hungry for humanizing glimpses of the famous and forceful modernist whose life seems as much a work of art as her creations. And also, it is a look at relationship—between two women, and between Wood's younger and older self. What do we understand years later about an experience? And how do we allow memory its own freshness?

Wood does justice to all of these aspects. The setting for this journey of discovery was O'Keeffe's Abiquiu home and the nearby Ghost Ranch, but it also includes the broader environment of village life in Northern New Mexico and the international art scene. From observations on watercress growing wild by nearby springs—utterly local in its habitation—her writing spreads like a patterned mosaic, detailing more and more of what she observed and experienced.

And the reader is infinitely richer.

Remembering Miss O'Keeffe

·WEAVING A NEW LIFE·

In 1977, when I was twenty-four, I chose a path that drew me away from an ordinary life. From Lincoln, Nebraska, I ventured to Abiquiu, a small village in Northern New Mexico, for work with the painter Georgia O'Keeffe. An acquaintance of mine was a companion to Miss O'Keeffe at the time. She cooked and provided assistance to the eighty-nine-year-old painter in many aspects of her life as Miss O'Keeffe's eyesight began to fail from macular degeneration. My friend was looking for someone to take her place and called to ask if I'd be interested. My response was an enthusiastic "Yes!" After being interviewed by Miss O'Keeffe and her business manager, Juan Hamilton, I was hired for the job, with responsibilities from suppertime through breakfast. I was both thrilled and nervous.

Juan had arranged for me to rent a small house in the nearby village of Barranco. Built in the 1940s, it had been the village schoolhouse, a simple pink adobe divided into four rooms and a bathroom. An upright piano sat in the kitchen, a reminder of school days. A large propane tank outdoors fueled the heaters and an old cookstove that worked admirably for cooking and baking. I learned to carefully monitor the gauge on that tank; otherwise, I could run out of fuel in the middle of winter. I lived simply, with a plywood plank on cinder blocks for my bed and orange crates for bookcases. Although the house was minimally furnished, it had plenty of room.

The village of Abiquiu fifty miles north of Santa Fe had a population of about four hundred people served by a general store, gas station, and post office. Barranco, with a population of less than one hundred, was a mile and a half from Abiquiu with no signpost at the turnoff. Life in my small, isolated village was exceedingly lonely at first. Every day I thought of my family and good friends far away. I focused on them one by one, and earnestly hoped they were remembering me as well.

Gradually I became acquainted with my Barranco neighbors. On one side was Willie from New Jersey, who had arrived a year before me. He worked as assistant dining hall manager at Ghost Ranch, Miss O'Keeffe's home prior to moving to Abiquiu and by then a ranch and retreat center. He was my age, had a good sense of humor, and provided supportive friendship. On the other side lived a World War II veteran and his disabled wife.

Across the road lived a kindly grandmother, and down the road my landlord and his family. His wife was the postmistress, and her sister, who was mentally challenged, would come into my kitchen if I forgot to lock the back door and play with the flour and sugar, leaving trails of white on the countertops and floor. Two ten-year-old boys from the neighborhood visited me to use the telephone or to show me their latest treasures, from arrowheads to tarantulas.

I worked at Miss O'Keeffe's Abiquiu house through the nights and into the early mornings, so my days were free for chores and other interests. One involvement was working part time dyeing yarn and weaving for a couple in nearby Medanales, Nancy and Janusz Kozikowski. They had four children, raised chickens and goats, tended a garden, and had developed a home-based business producing natural-dyed weavings, which they sold from their home and in galleries. They taught me how to dye wool with yellow and orange made from the native chamisa and cota plants, as well as other colors of dyes from onionskins, walnut hulls, Brazilwood, and indigo. I admired the many skeins of yarn hung out to dry after a day's work: dark colors to paler hues as the dyes became less potent. Indigo was the most intriguing color, first appearing yellow, then changing to blue as oxygen interacted with the chemicals in the dye when the yarn was exposed to the air.

The Kozikowski weavings featured landscapes and traditional designs with a contemporary flair. From them I first learned how to weave stripes, then a variety of shapes using a simple tapestry technique. Under Nancy and Janusz's direction, I wove New Mexico hills,

sunsets, and billowing clouds, blending yarn colors from light to dark to achieve a painterly range of contrast.

Some mornings after a night's work with Miss O'Keeffe, I would jog down the narrow dirt road from my house to the Chama River. It was a mile or more on soft dirt, lined with grand old cottonwood trees, the river on one side and gently banked hills on the other. Barranco was a place of unkempt beauty: barbed-wire fences around overgrown fields, simple adobe houses, a small apple orchard inside an old stone wall, one modern solar home next to a ramshackle corral with a few horses. Occasionally I took hikes on the U.S. Forest Service land that surrounded my village along rugged sandy hills to shallow, wind-carved caves of sandstone and a little waterfall high enough to stand under for a refreshing shoulder massage. I found a few arrowheads on my hikes, and on one occasion I saw a small bobcat.

On summer afternoons, I often swam in Abiquiu Lake, a body of water formed by Abiquiu Dam north of the village on the Chama River. My favorite spot to rest was a group of large flat rocks at the water's edge. I rarely saw another person there. I savored the solitude as I gazed at the clear water and the steep, rocky shores dotted with cedar and piñon trees.

During the summers, I took part in a few short courses given during the day at Ghost Ranch—Spanish, spinning, and woodcarving. In the woodcarving class, I whittled my piece to practically nothing. Spanish was both challenging and rewarding at a beginner's level for basic phrases. My favorite class was spinning. As I gained control of the fibers there was immense satisfaction from making long, smooth strands of yarn that gently, naturally twisted together.

Over time I became enchanted by life in Barranco. The piano kept me company in my kitchen. A corral with a few cows was the view from my dining room window. I heard the springs rush through the irrigation ditch nearby. I learned a little local Spanish with study and my neighbors' help. Dyeing yarn and weaving were my creative endeavors. And my work with Georgia O'Keeffe was unique and tremendously inspiring. I was fortunate to have her guidance for that time in my life, and it endures.

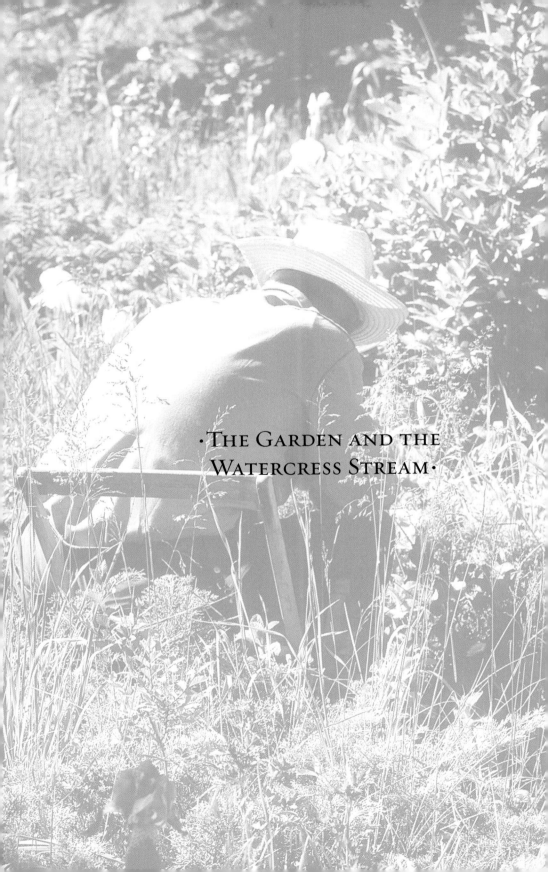

· The Garden and the
Watercress Stream ·

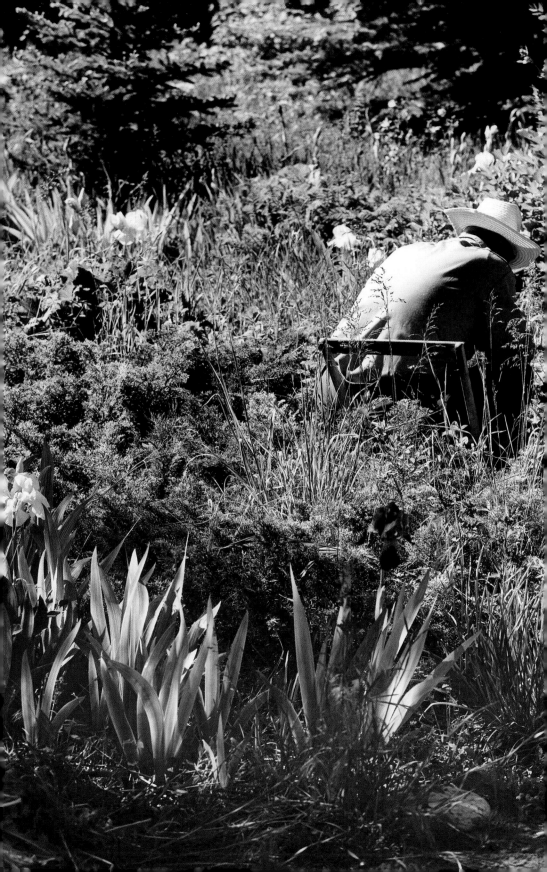

Growing, preparing, and partaking of her own fine food was one of Miss O'Keeffe's greatest pleasures. She had planned and worked her organic garden for twenty-five years when I was first introduced to it in August 1977. We walked slowly through the large array of vegetables, herbs, flowers, and fruit trees, as I carried a straw basket for the vegetables she selected for that evening's supper.

Because her eyesight was poor and my knowledge of garden plants was limited, she described the shapes of leaves and the way plants grew to make sure I knew what we were inspecting. I was familiar with the bright daisies, sunflowers, and hollyhocks that were in full bloom. Describing how she saw the flowers, she said she could see the outer petals but the center of the flower appeared very soft, barely there. "You couldn't see it the way I do," she said. "It's really quite beautiful." Her central vision had deteriorated, although she could perceive color and form in her peripheral vision.

As we continued with the garden orientation, I easily identified corn, string beans, tomatoes, broccoli, zucchini, and cucumbers. However, the different cabbages, lettuces, and leafy greens, as well as the many small-leaved herbs, were confusing at first. Time and patience were required on both our parts for me to know the plants well.

The lettuces had distinct flavors, from delicate to strong. Miss O'Keeffe taught me about carefully picking the many varieties, a few leaves at a time, then washing them and storing them meticulously for daily use This detailed approach to preparing the lettuce was just one example of the precise way in which household tasks were to be carried out.

The Abiquiu garden had abundant raspberry bushes that supplied a ready treat as I gathered the garden offerings Miss O'Keeffe requested each day. However, I learned on one occasion a perilous aspect of raspberries—they made stubborn stains on a cork floor. One evening I was tidying up the pantry after supper, and while eating a handful of raspberries, two or three slipped through my fingers onto the floor and were stepped on. Red stains immediately spread over a large area as the cork absorbed the juice. I quickly grabbed the fugitive, flattened raspberries, then scrubbed the cork floor with soap and water. But at night under dim light I couldn't tell how well my cleaning had succeeded.

The next morning when the housekeeper arrived she reported the alarming raspberry stains to Miss O'Keeffe. When I admitted that I was the culprit, Miss O'Keeffe instructed me in the method for cleaning up the unsightly marks: baking soda and water combined with hard scrubbing with a stiff Mexican cleaning brush. I had to attack the raspberry stains on several attempts before they began to lighten. Sitting on the unforgiving cork floor, scrubbing as hard as my arms could manage, I hit my head on a pot that hung from a low hook along the plastered adobe wall. I felt totally humiliated. Georgia O'Keeffe should have tile floors, I thought, and she shouldn't get so upset about small spots.

At the time, I hadn't yet fully realized the need for attentive care and daily order in a household run for a woman who couldn't see well and needed to know that her uniquely beautiful environment was being tended carefully by the people who worked for her. In my daily duties, I had to learn to gracefully and willingly perform multitudes of ordinary tasks in the specific ways that she preferred.

I often wondered how long it would take to actually become friends with this fascinating, difficult, and demanding person. In retrospect, it took as long as was required for me to want to shape her world in the way she desired. But the required time seemed like forever. In moments of frustration I would say to myself, "I think I can do this for one more month; maybe by then she'll be more pleasant."

At first, my nerves were always on edge, and I often suffered from intestinal distress. I tried to brush her hair with just the right amount of pressure. I ran her bathwater at the most pleasing temperature. I concentrated on cooking the millet grains just the way she preferred. Although I was discouraged from time to time, I persevered because it was enchanting working with this legendary artist in her remarkable setting. After nine long months, I began to understand how to respond to her needs, yielding more like a willow in the breeze rather than being a stubborn young woman. Gradually, Miss O'Keeffe and I began to have more fun.

After a particularly pleasant meal, she asked, "Don't you have a sister who would be as useful to me as you are?" I worked weeknights and one weekend a month, but Miss O'Keeffe needed assistance on the other weekends. She was so particular that she kept Juan Hamilton occupied searching for women who could work for her. His choices were not always well received. Miss O'Keeffe let us all know when the "weekend girl" had been noticeably poor. "I could break her in if I wanted to, but I just didn't like her," she might say. I silently counted my blessings that I had finally gained her approval after a time of trial.

During my first spring in Abiquiu, the gardener turned the soil, prepared rows of rich, dark earth, and planted seeds. In late May, a variety of sprouts began to emerge. Miss O'Keeffe and I would walk along the paths beside a low stone wall where red-orange poppies opened out among delicate blue, purple, and yellow iris. Lending their scents to the warm evening air, lilacs and tamarisk bloomed along the high adobe wall that ensured privacy for the property.

Miss O'Keeffe especially enjoyed the first snow peas that peeked out from their leafy vines. She showed me how to pick peas that were just right, not oversize and fibrous but about two inches long and tender. I also picked young dandelion greens, not yet bitter, and chopped and sprinkled them into mashed potatoes. Early parsley, chives, and tiny radishes graced the salads.

The herbs were a delightful discovery for me. I knew about dried oregano, rosemary, mint, and parsley, but I was unfamiliar with the flavors of fresh tarragon, basil, lovage, thyme, sorrel, and summer savory. I learned that the addition of lovage, which tasted much like celery, created a subtle difference even in a bowl of Campbell's tomato soup.

Miss O'Keeffe was especially fond of deviled eggs, with a different herb finely chopped and added to each yolk. It was nearly impossible for me to chop sufficient little green leaves for her to be satisfied that

enough herb was stuffed into each hard-boiled egg, but they were very pretty with their different colors and textures of green. I also used a variety of finely chopped herbs mixed into olive oil, lemon juice, and garlic for salad dressing, freshly made for each meal. Adding sorrel to the salad gave it a fresh, slightly sour "green" taste, while a few tender spinach leaves and sweet young radishes lent an earthy flavor.

From summer through early fall, we carefully steamed each vegetable so that the garden offerings were not crunchy but tender and retained their bright colors. Spinach was one of the most difficult vegetables to prepare perfectly because it cooked so quickly. We determined that between two and three minutes was best so that the leaves were slightly intact but soft enough to cut with a fork. Kale, wrinkled and leathery, was the toughest vegetable and required the longest steaming time. Occasionally, we undercooked it and had to put the stubbornly resilient vegetable back in the steamer to finally make it tender enough to chew. The rewards were the intense flavor and the many vitamins in this hardy green.

Another highly desired green was not to be found in the garden. Watercress grew along many springs and irrigation ditches. "You can find watercress along the banks of the springs in Barranco—go look," Miss O'Keeffe said. My village water came from springs in distant hills and had been channeled through ditches, called *acequías,* for many generations—water for drinking and washing, for gardens and fields. Gravity created the gentle current that eventually led the remainder into the Chama River. From my house, I could hear the rushing sound of a little waterfall along the ditch system.

In search of the coveted watercress, I would follow the ditch upstream as it ran beside a few houses, then into sandy hills overgrown with burrs and Russian olive trees. At first, I found very little of the jewellike watercress clinging along the water's edge, but farther into the hills I had my first glimpse of thick, rich green leaves floating at water level, anchored to the banks by long roots. It formed a thick, green border glistening on both sides of the ditch, with the smoothly gliding stream running between.

I began gathering cress from where I stood beside the stream but soon found it was easier and more pleasurable to pick it by stepping into the stream. The gently flowing water was invigorating. I discovered that the process was to pick the cress above the roots so that more leaves would grow. I encountered some large-eyed water insects, disguised in the thick growth, and seeming rather protective of the water-

cress. They pinched my fingers when I plucked them up with the cress, so the challenge was to first wash each handful of cress thoroughly in the moving water.

I gathered watercress both in summer and winter, since the greens grew year-round in the constant temperature the springs maintained. Once I collected the cress as it was snowing, bunches of emerald green in my hands, white flakes adorning them. In the summer, little white blossoms graced the plants, and we had blossoms in our salads. When the watercress was young and had small leaves, the flavor was mild. When the leaves were larger and blossoms appeared, the flavor was hot and deep.

Two times during the year watercress required more effort to find. In early spring and mid-autumn, the village people cleared the lower portion of the ditch of weeds that otherwise would choke water flow. The periodic cleaning was an age-old tradition led by the *mayordomo*, elected overseer of the irrigation ditches. Every household receiving water from the ditch was responsible for supplying at least one individual for the seasonal cleaning duty. On the appointed weekend morning, the stream was diverted to an alternate route. Mostly men and some women and young people gathered with large shovels to clear the banks of obstructing plants and brush. One day after the lower part of the ditch had been cleared and my usual gathering source was practically bare, I walked farther up stream to find the precious greens. I followed along grassy banks and overgrown trails, avoiding Russian olive thorns and skirting the delicate tamarisk shrubs. Eventually the trail became steeper to expose rock along the streambed that over time had naturally carved the watercourse. Above the rock was the water source in a quietly seeping grass-filled spring.

When I brought watercress for the salad that evening, I had a wonderful tale to tell Miss O'Keeffe about discovering the springs and the thick cress above the cleared ditch. She enjoyed hearing about my explorations in this area she loved. She said that she liked to think about people "tearing around" in the hills and mountains—there was nothing much better than that. I agreed.

· EVENING RHYTHMS ·

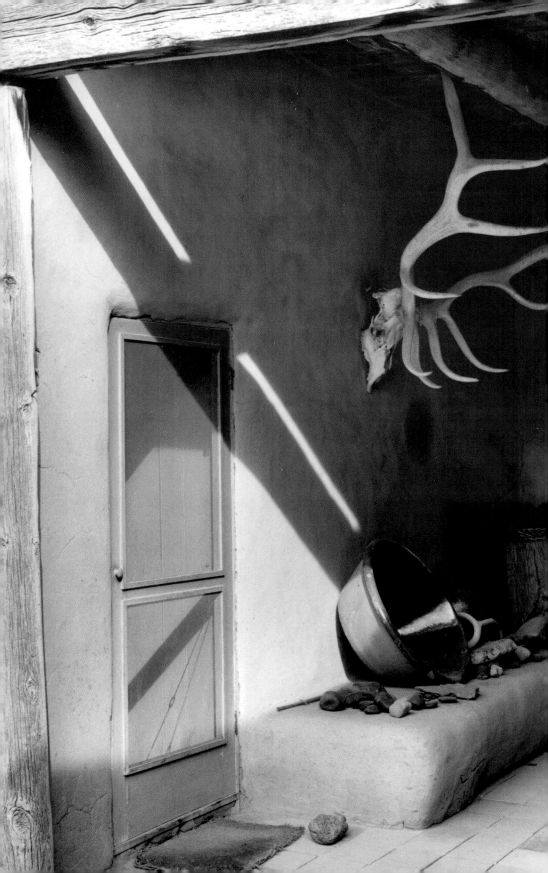

I worked for Miss O'Keeffe most nights for nearly three years, arriving late in the afternoon and remaining until after breakfast the next morning. After that I worked many weekends and occasional nights. In good weather, I walked one and a half miles from my house in the center of Barranco along the road built into a steep cliff beside the Chama River, then turned south toward Abiquiu and Miss O'Keeffe's home inside her thick adobe walls.

By the time I arrived at five, the daytime staff, all members of the same family, had gone home. I appreciated the simplicity and peacefulness of that time when only Miss O'Keeffe and I were there. I would call out my greeting, and she would respond. She said she knew me by my voice and the way I walked, but she couldn't clearly see my face due to her failing eyesight.

Before supper we often walked the large circular driveway, gazing at the Chama River below, the long mesa to the east, and distant mountains in several directions. As we strolled, we admired the apricot, peach, and apple trees on her hillside terraces. On the far side of the driveway, within the garden wall, two locust trees grew toward each other "like old friends," Miss O'Keeffe remarked. She used a cane as she walked, and only occasionally needed a steady arm in hers as she gracefully, resolutely proceeded with her exercise.

We tried different rhythms for walking and a variety of approaches to maintaining good posture or achieving maximum circulatory benefits. As suggested in articles we had read in health magazines, we tried walking as if holding a coin between our buttocks. Another trick was to emphasize the first step in every three, to improve walking stamina. She would place a stone on her low adobe windowsill after each wide turn we completed. Sometimes there were four stones, other times eight or nine.

After a walk and supper, we often listened to music in her studio as night approached. She would sit in a comfortable modern chair with her feet propped up on a stool, facing her large, spiraling white sculpture placed in front of her abstract painting *From a Day with Juan*, their forms imposing along the expansive white wall. I would gaze out the enormous studio window at the mesa across the river, the ever-changing clouds, the swooping birds, and the colors of the darkening sky. One evening I had just placed the stool under Miss O'Keeffe's feet and covered them with a white woolen throw when she said, "I hope you have someone to do this for you when you're my age." Her kind remark surprised and touched me.

Some of her music selections were Pablo Casals's Bach cello suites, early music of Gesualdo and Monteverdi, and classical works by Mozart, Schumann, and Beethoven. She was pleased when someone enjoyed sharing her fine collection. Our serene interior, as well as the grand landscape outside, seemed filled with music.

Later, in preparation for bed, I would brush Miss O'Keeffe's long hair firmly but gently as she sat dressed in a beautifully ironed white cotton nightgown. Then we would enter her bedroom, with its painted black floor, white bedspread, and natural reddish-brown adobe walls. Beside her small fireplace was a bronze sculpture of Buddha's open palm in a gesture of blessing. A corner window had been made from two large adjoining plates of glass. She commented that the large windows made her feel as though she were sleeping "right out in the fields." In the summer at night, I pulled the curtains wide open so she could see the brightest stars. In the winter, I covered her forehead with a soft, lightweight silk scarf to keep her warm.

Before she went to sleep, I read aloud to her from widely varying works of her choosing, an activity she had loved to do herself prior to the onset of macular degeneration. She said that formerly she enjoyed reading cookbooks at night, as recipes were short and one could begin any place in the book. At times she used a special phonograph designed

for listening to records of current news sent weekly from *U.S. News & World Report* or the *Christian Science Monitor*. She looked forward especially to receiving the bold-print *New York Times*, a much-condensed version of the regular newspaper. Her favorite column was by Russell Baker. She thought she should invite him to dinner because she enjoyed his writing so much. I would sit on a low chair beside her bed and read from books and magazines about art news, philosophy, political events, travel, health, and other topics. A few books we read were the *Tao Te Ching*, one on Chinese poetry, the Chinese folk tale *Monkey*, and a biography of Mark Rothko. When Miss O'Keeffe awakened in the night, which was often, if it wasn't too late she would call out my name and ask to read again until she fell asleep.

I spent the nights in the large adjacent studio, sleeping in a single bed covered with a simple white cotton bedspread beside the immense window to the outside world. Lining the deep windowsill were various bones and large smooth rocks that provided mysterious shapes at night, silhouetted by moonlight. There was much grace and inspiration in Miss O'Keeffe's environment of cultivated simplicity. Sometimes at night, as I laid in bed, on smooth, white sheets beneath a window of star-filled sky, I reflected on this remarkable world I'd entered with quiet pleasure. As the months rolled on, I began to feel more relaxed with Miss O'Keeffe. I enjoyed the work, dedicated to a remarkable elderly person who lived in a clear and focused way. I felt as though Miss O'Keeffe was a guardian for me as much as I was for her, that our exchanges were both giving and receiving.

·Through High Adobe Walls·

A high, expansive adobe wall surrounded Miss
O'Keeffe's Abiquiu house, separating it from
village activity and intrusions. At first Miss O'Keeffe seemed seques-
tered from the village and the rest of the world, venturing out only
to Ghost Ranch, where she spent much of her time in the summer
and made occasional trips in winter. The ranch was even more isolated
than Abiquiu.

Over time, however, I found there were many in Abiquiu and the
surrounding area who were connected to her world. A remarkable mix
of local people had known the artist for decades, many since they were
children. In addition, she had several friends in Santa Fe, from the art
world, and other connections. A great number of individuals nearby
and far away reached out to her.

Although she was somewhat reclusive behind her adobe walls
and protective of her privacy, Miss O'Keeffe knew and trusted sev-
eral people who had grown up around the village. One longtime friend
was Carl Bode, proprietor of Bode's General Store in Abiquiu. Miss
O'Keeffe recalled that when she first came to Abiquiu his German
father could be counted on to sell good dark bread and cheese, along
with other useful inventory, from nails and tools to sugar and milk.
Bode's was also a gas station. For the many articles not carried, such as
green vegetables and kitty litter, it was necessary to venture to Espa-
ñola, twenty-three miles south.

On many occasions, Mr. Bode helped protect Miss O'Keeffe's privacy. If passersby driving along the main road stopped to ask where she lived, he told them he didn't have any idea and had heard that she was a very private person.

Her occasional handyman Johnny she had known since he was a little boy. As a grown man, he helped with a few chores around her house when he could take time from his business. His wife, Rosalia, was a good seamstress who stayed overnight with her in a pinch.

Johnny and Rosalia's son was married in the Holy Family Catholic Church in Chimayó, a ceremony Miss O'Keeffe attended with Juan. I was Miss O'Keeffe's companion that weekend, so I was included as well. The reception offered a traditional meal and live music. Northern New Mexican foods were served: *tamales*, *enchiladas*, *carne adovada*, and *posole*. Smells from the red and green chile were tantalizing, but my first taste of Chimayó red chile caused tears to come to my eyes. A young band played both popular songs and Spanish *ranchera* tunes, with their polka-like rhythm. The bride and her father were the first to dance. Friends pinned money to her dress for good luck. Miss O'Keeffe spoke with the parents of the groom as she enjoyed the meal. It was unusual for her to stay through the luncheon. Miss O'Keeffe rarely ventured out for meals; she said she always ate best at home. Also, there were no restaurants near Abiquiu.

Another rare lunchtime outing was with her two sisters and niece at a Chimayó restaurant one autumn weekend. It was uncommon that three family members were visiting at the same time. Her sister from California always came for the summer to help with the garden. Another sister and a niece visited infrequently from Wisconsin. On this day, Miss O'Keeffe caused a stir in the restaurant after the hostess recognized the famous painter. We asked for a table in the back corner of the hacienda.

I read several selections out loud from the menu. Miss O'Keeffe ordered a vegetarian plate with cheese enchiladas. After she took a few bites, she remarked that her meal was "entirely indigestible." When I examined her food, I realized they had left out the cheese. The waitress brought her another enchilada, but by this time she had lost interest in the whole experience. This only reinforced her premise that the best meals were prepared in her own home.

In the search for quality food for her household, Miss O'Keeffe had met a local woman with the reputation for selling excellent eggs who lived south of Abiquiu toward the El Rito turnoff. Miss O'Keeffe would call Gregoria and ask in basic Spanish if the elderly woman had eggs that day.

Then I would drive us in the white Mercedes to a little adobe home where Gregoria's wrinkled and smiling face would greet us. "*Gracias, gracias,*" Miss O'Keeffe would say when the woman brought us two or three boxes of carefully washed brown eggs.

For many years, Miss O'Keeffe had hired village people to cook and do household and garden chores. One evening we attended a rosary for a man who for forty years had helped with odd jobs and brought wood to her. His wife, who survived him, had worked in Miss O'Keeffe's home for many years as well.

As it was a warm spring evening and the village church was nearby, we walked down a short stretch of dirt road and through the large open plaza. Bordering the plaza were the modern village gymnasium which Miss O'Keeffe had funded, a small bar, and a few old homes. As we neared the church, she greeted several village people she knew.

The church was less than a hundred years old, a simple but lofty structure with a balcony at the rear. We sat on the ground floor in the back. Miss O'Keeffe whispered to me, "I used to sit in the balcony, but the floor creaked so much I was afraid I would fall right through." The church was sparsely ornamented with geometrically patterned clear glass windows, the fourteen stations of the cross, and a carved wooden crucifix. After the service, as we walked back to the house Miss O'Keeffe said she felt as though the world had changed upon the passing of this man, whom she had known for so many years.

The Lopez family who now worked in the O'Keeffe home represented three generations. The grandfather, Steven, was the gardener and handyman. He spoke mostly Spanish. Miss O'Keeffe recalled her heated discussions with him about how to plant corn—with his method, making heaps of several seeds, or her approach, planting single seeds at regular intervals. She claimed that she always won the arguments.

In the summer, on days that the household was allotted to receive water from the *acequia*, Steven channeled streams from the main irrigation ditch into smaller ditches in the garden and on the fruit tree terraces.

He planted vegetables, picked fruit for canning and drying, and weeded the large garden. In the winter, he split and arranged beautiful vertically layered kindling in the many fireplaces. Because the layers were graduated in size, with shorter, small kindling in front, only one match was needed to start a fire.

Steven's daughter, Candelaria, was the housekeeper and cook. She kept the house in impeccable order, cooked the noon meal, and performed a myriad of other tasks from baking bread to drying fruit and

herbs. One of her specialties was a raspberry dessert. I knew that it was made with raspberries and gooseberries and was strained through a sieve, but Candelaria never revealed the other ingredients for this delicacy.

Candelaria's daughter, Pita, was a companion when needed and a secretary. In her quiet and natural manner, she looked after Miss O'Keeffe's needs in an efficient way, attending to a range of responsibilities. She later became Miss O'Keeffe's business assistant, working closely with Juan Hamilton.

Pita's three brothers helped their grandfather in the garden and maintained the house. They also assisted Juan with his large sculptures. The Lopez family loyally tended the O'Keeffe household.

Visitors usually made appointments with Miss O'Keeffe on weekdays when the family staff was present. Very few people came during the evenings, but one night a handsome young lawyer from a nearby village dropped by. Miss O'Keeffe had helped him with his educational expenses, and he told her about his growing practice near Española. She laughed at his outlandish tales about unusual cases.

From time to time, an Abiquiu village representative would speak to Miss O'Keeffe about the needs of the town. Over the years, she had contributed to renovating the ditch irrigation system, to the volunteer fire department, and to restoring and protecting two *morada*s, the meetinghouses of the Penitente spiritual community.

Quite a different visitor was the woman who designed Miss O'Keeffe's white and black dresses, all sewn from the same pattern, with a slightly fitted bodice and fuller skirt in a wraparound style with ample collar and lapels. A wide belt of the same fabric hooked neatly in front, at the center of the waist. Miss O'Keeffe wore her signature "OK" pin designed by Alexander Calder on her right lapel.

In the summer, she wore the white dresses, in winter, the black ones. She owned several pairs of black Ferragamo shoes, all the same simple style that she found most comfortable. She never changed her habit of dress during the time I knew her. Although she searched for another comfortable dress design in Santa Fe shops, she never succeeded in finding one.

An unusual guest was a Los Alamos scientist who became Miss O'Keeffe's friend. He enjoyed describing his research projects and invited her to tour the huge particle accelerator at Los Alamos National Laboratory. I drove Miss O'Keeffe and her sister up the winding road to the mesa-top facility. We entered a gigantic room with a long, curved white tube of large diameter. Small chutes angled off at different points along the major tube. Research was done with specific particles split

off an atom at different intervals. One area of research was studying the effects of directing particles at tumors. The Los Alamos visit was fascinating to all of us, although the facility we saw was such a foreign environment that we had difficulty describing what we had seen.

A new friend for Miss O'Keeffe was a Japanese violinist with the Santa Fe Chamber Music Festival. Miss O'Keeffe had given permission for the festival to use her paintings on their posters, and the group gave a concert to honor her annually. She had enjoyed talking with this musician, so she invited him and his family for a light supper. When they arrived early, we involved them all in making homemade mayonnaise. There was much laughter between talk of food and music as we slowly drizzled oil into the egg yolks in hopes that the condiment would turn appropriately thick for our sandwiches.

Sometimes the O'Keeffe household received celebrity guests. I was quite disappointed that I did not get to meet Ansel Adams, Louise Nevelson, Joan Mondale, Ralph Lauren, or Pete Seeger, but I did meet Allen Ginsberg, Joni Mitchell, and the South American artist Marisol.

One summer evening I arrived to find Allen Ginsberg and his partner, Peter Orlovsky, at the house. They admired the late afternoon light as they compared the nature of words to action. Miss O'Keeffe commented that talk was easy—it was action that got things going. Ginsberg responded that words often inspired people to action. He and Peter climbed the ladder to the roof to watch the sunset. I was enthralled by the company as I quietly prepared supper.

Another guest was the popular folk singer Joni Mitchell. She was a painter herself and had admired Miss O'Keeffe's paintings. During supper, she had many questions for Miss O'Keeffe. I think the older artist felt adored by her glamorous guest. Joni gave Miss O'Keeffe one of her records and urged her to listen to it that evening. After supper, Miss O'Keeffe and I walked to the studio and played it. She remarked after a few songs, "Margaret, why are the young people in such a stitch about her? This music makes me drowsy." She didn't tell Joni what she thought.

Miss O'Keeffe generally accepted only good friends or special people who had arranged appointments as visitors. But one morning she uncharacteristically allowed into the gates a young woman who had been knocking at her bedroom window. The two had a brief conversation, then the woman left, looking as though she had been granted her dearest wish. There was a rich and sometimes unpredictable flow of activity between Miss O'Keeffe's domain and the world on the other side of her high adobe walls.

·Tales from the Past·

Miss O'Keeffe was a treasure trove of stories from her ninety years of colorful experiences, but it wasn't just the stories that were intriguing—it was the way she spoke. Her distinct vocabulary and style seemed crafted from many repetitions of the same stories, told in simple but precise words and the charming manner of generations past. When Miss O'Keeffe spoke about her experiences, she often remarked that she had lived many lifetimes.

I pictured Miss O'Keeffe's childhood in rural Wisconsin at the end of the nineteenth century as she described her family's large barn smelling of horse manure, cows, and hay. She spoke of cold winters when she would briskly walk to the barn, snow crunching under her boots, and ask the groomsman to saddle horses for pulling the sleigh. She recalled sleigh and toboggan rides in the moonlight. Bundled up in her warm coat, she made "angel" imprints by lying down in the snow and waving her arms like wings. She enjoyed square dancing to her father's fiddle music in a neighbor's large dining room.

In the fall, people would stop at the large apple orchard on her family's farm and pick as many apples as they wanted while the O'Keeffe children sat on the fence. That was perfectly acceptable as there was plenty of fruit for all, she said.

Miss O'Keeffe also remembered her pleasure when her mother read to the five children from James Fenimore Cooper's *Leatherstocking Tales*, stories by Rudyard Kipling, and chapters from the Old Testament. She must have adored her mother because she said that, as a little girl, she always made her mother's toast and would cry if someone else did. She remarked that she was not a favorite child, so she was usually left on her own to do what she liked.

Miss O'Keeffe loved exploring the outdoors when she was young. During the spring rains, she once used her socks to collect small frogs from postholes along the fences. She wasn't allowed to bring them inside the house but was told to leave them in a pan outside, and of course they hopped away by the next morning. A curious child, she put egg yolks on her windowsill just to see what would happen.

She described many experiences unknown to my generation. When she was older, a friend who lived on a nearby lake would often wait for her after school to take her across the water in his iceboat. The craft could sail on water as well as ice. "You would lie down in a little heart-shaped box and let the wind take you," she said. She remembered her family's large, dark room that held blocks of ice cut from a frozen lake close by and packed in sawdust—enough ice to last the whole summer.

She often told about experiences in her New York life with her husband, photographer Alfred Stieglitz. He had established the modern art gallery 291 and mounted her first exhibition there. Considered by many to be "the father of modern photography," it was his fondness for sports that Miss O'Keeffe recalled. "Everyone thought he enjoyed the Arts Section of the *New York Times,* but he cared nothing for that," she said. She talked about his passion for racehorses, remarking that as a child he had played with toy horses and jockeys that he set up for races. As an adult, he kept a diary on his favorite horses.

Miss O'Keeffe said that Stieglitz was extremely vocal with his opinions on art and politics. He expected his circle of friends to agree with his views, but from morning to late afternoon his opinions could change, so that people quoting him might contradict his most recent pronouncement. She commented that his changeable ways were rather confusing for some in Stieglitz's group of artists, writers, and musicians.

Miss O'Keeffe and Stieglitz left New York City to spend summers with the Stieglitz family at Lake George. She told how she and Stieglitz would paddle a canoe out on the lake after supper to watch the light fade over the mountains and water. Stieglitz's mother would always stay on the veranda and watch until they returned "because Alfred

didn't know how to swim," she explained. In winter, the ice on Lake George became very thick. Miss O'Keeffe sometimes drove her car to the edge of the lake, thinking she would drive onto it, but she never summoned the courage.

Miss O'Keeffe also told stories of her early days in New Mexico. She spoke of becoming "as black as possible" under the intense rays of the sun. When she painted in the summer, it was so hot that she had to rest under her car to stay cool. When it was hot at night, she slept in her rooftop bed at Ghost Ranch.

She spoke of her pleasure at finding new areas of the countryside to explore and paint, and discovering new ways to look at the world. She loved walking in the hills around Alcalde when she first came to New Mexico, then around Ghost Ranch and Abiquiu. She said, "If I couldn't get along out here by myself, I wasn't worth much."

She spoke of feeling free and finding her place in Abiquiu. To her, *place* was the most important thing. She urged me to find the place that I loved and gave me another bit of advice: "It's not enough to be nice in the world; you have to have nerve."

·THE BLANK CANVAS·

One weekend morning Miss O'Keeffe announced that a canvas had been prepared for her. After breakfast she entered the small bedroom studio space with anticipation. We inspected the large rectangular canvas on the easel pulled taut and stapled over wooden stretcher bars. I could see that the awaiting surface was the color of light gray linen. She touched it and realized it had not yet been prepared for painting. No coat of gesso had been applied. The raw fabric was without the acceptable surface for her paint.

She relied on one young gardening assistant she had taught to prime her canvases. This time he had not completed the requested task, and Miss O'Keeffe was noticeably disappointed. She would now have to wait until the gardener returned to work after the weekend. She expressed dissatisfaction at her inability to prepare her own canvases and carry out her work independently. Later that week she worked on her painting with the gardener's help.

A few weeks later another canvas was prepared for her. She asked me to assist with sections of a painting in her abstract series *From a Day with Juan*, one of several paintings of her impressions of the Washington Monument from when she and Juan had traveled to Washington, DC. Upon visiting the imposing obelisk, she had become enchanted with the appearance of the towering monument through her altered eye-

sight. She was so inspired by this that she dedicated a series of paintings to the idea.

This day Miss O'Keeffe wore a full-size faded but clean denim apron and dressed me in a muslin one. On the primed canvas she had drawn in charcoal two vertical lines angled slightly toward each other, outlines of the obelisk. The areas inside and outside this shape were divided into several horizontal lines that delineated changes in shading. Using oil paint, light to dark values in gray and blue, she portrayed the effect of looking up at the immense 555-foot-high obelisk with blue sky surrounding it. The marble monument was pale gray at eye level and darker gray higher up. The sky deepened to darker blue on both sides.

She carefully painted areas that blended from a lighter to a darker color, though some sections remained slightly linear despite Miss O'Keeffe's attentive brushwork. I painted areas of solid gray in long horizontal brushstrokes as she directed. The next day I painted sections of blue. I watched as she blended the colors, painting with confidence and grace. I once heard her tell a friend, "If you know what you're doing, you don't have to see it."

Miss O'Keeffe enlisted the assistance of a few people on her staff to paint horizontal sections of flat color in this series of paintings. Careful records were kept concerning who had assisted with which works. I signed the document that I had been an assistant for that one particular painting. Her use of assistants was documented in ArtNews in 1980, Miss O'Keeffe asserting that using an assistant in this way was like using a palette knife, a tool. She was quoted as saying that the concept for the painting was hers—and the concept was the most important thing.

The series attracted much attention due to her change in style compared to the meticulous technique and greater detail seen in her previous work.

During this time, Miss O'Keeffe also painted a series of watercolors with large brushes. These were elegantly balanced designs—simple dots, circles, and bold lines—in single hues. Juan encouraged her to paint and also introduced her to working with clay as her eyesight dimmed. She said that she felt much more familiar with paint despite the ease of shaping soft clay.

One evening the man who framed Miss O'Keeffe's work brought to her studio several of her drawings and paintings created within the past ten years. The newly framed works were placed on the white car-

pet in a large circle around the perimeter of the room. A few were bold watercolors in dark blue. One was a pastel study in the series *From a Day with Juan*. Each piece was distinct, emanating vitality, beauty, simplicity, and impeccable design. After Miss O'Keeffe looked at them, she left them in place overnight. My bed a part of the great circle, I slept among those splendid companions.

· LAND OF RED HILLS ·

M iss O'Keeffe's first New Mexico home and the place where she spent much of every summer was north of Abiquiu at Ghost Ranch. Her unassuming adobe dwelling, which she rented and eventually purchased from the dude ranch owners, was surrounded by a magical landscape of horizontally banded sandstone cliffs and the flat-topped volcanic mountain called Pedernal to the south. She said it was here that she felt truly free. There was open space everywhere she looked, with no surrounding wall as at Abiquiu. It was for me a pleasure to drive to the ranch through the enchanting landscape down a meandering, unmarked dirt road through the red hills.

In the early evenings, we often walked the narrow red-earth trail toward the cliffs, Miss O'Keeffe's black and honey-colored chow dogs prancing along with us and taking off if they spotted a rabbit. We strolled at a moderate but constant pace, Miss O'Keeffe using a wooden cane to steady herself. I walked beside her, sometimes stopping in the long shadow of a cedar tree. When she decided to go no farther, we turned back toward the ranch house, with its view of Pedernal. Although we never actually reached the base of the cliffs, it was the idea of doing so that she held dear.

When we returned to the house, I made supper from the fresh garden produce that I brought daily from the Abiquiu garden. We sat

at a table tucked into a corner window with views in two directions: the distant cliffs striped with yellow ochre and red, and the nearer red clay hills. The texture of the hills was like old skin—wrinkled and soft. Near one window was a pine tree that gently bowed in the wind. Miss O'Keeffe thought that when it moved it looked as though it was breathing.

Another pleasant place for meals was the patio, a rectangular space with rooms on three sides. Sagebrush grew in spaces between the flagstones. A large round sawblade mounted near the adobe wall made gentle sounds like a gong when the wind stirred it into movement. An unobtrusive fence supposedly built to keep the rattlesnakes out separated the patio from the expansive plains.

We sat on the patio many an afternoon gazing at the clouds and Pedernal. Often I read to her from the latest issues of *Time, National Geographic,* or *Prevention* magazine. Sometimes Miss O'Keeffe spoke about what kept her involved in life despite her creaks and her business aggravations. She said that most important was her interest in projects and future plans. At this point, she needed assistance for all of her projects—a series of abstract paintings of the Washington Monument, a book of her work, and a book of photographs by her late husband, Alfred Stieglitz. She was also interested in her dreams, dictating them when good ones came along. And she relished learning about new ideas and trying new recipes.

In her nineties, Miss O'Keeffe surrounded herself with young people, another way she kept her mind active. Many of the women who assisted her as companions were in their twenties. Juan was a man in his thirties. She had known him for five years when I came to work for her. He had assisted her with the book *Georgia O'Keeffe,* published in 1977. He directed her correspondence, and he increasingly influenced how her paintings were sold. He orchestrated the household staff as well. He could bring out her beautiful girlish laugh when he teased her. Although his changeable moods at times caused bruised feelings, I felt that he added spark and confidence to her life and inspired new directions and ideas in her world.

A key to Miss O'Keeffe's vitality appeared to be that she lived in a place she loved, in a pleasing manner that she had refined and by a schedule that suited her. She rose early and often practiced her foot, ankle, and leg exercises taught to her years before by Ida Rolf, who had developed the technique called Rolfing. After breakfast, Miss O'Keeffe dutifully swallowed a few healthy concoctions, including

brewer's yeast, blackstrap molasses, and lecithin. She had read about the merits of these foods and believed they would help sustain her health, although she did complain about their strange tastes. She took pleasure in drinking yogurt and goat's milk. She once had a woman friend who had raised goats, so at that time her yogurt was made from fresh milk.

Following this morning routine, Miss O'Keeffe would usually work on business matters and paint when assistance was available during the day. At Ghost Ranch, visitors were rare. In fact, hardly anyone knew how to get there.

In earlier days at the ranch she often slept outdoors under the stars. She put a cot on her flat roof and covered the bed with a rubber sheet to protect it when it rained. She had loved sleeping on her roof. She described how she used to walk the land at night in her nightgown, although she didn't do that after the Presbyterians purchased the ranch.

In the evening after a rain, when the smell of sagebrush was pungent, we would watch the sky for rainbows and survey the cliffs for waterfalls in familiar places. The summer sunsets were grand as we gazed from the patio and drank mint tea. Miss O'Keeffe would sometimes wave her hand into the landscape toward Pedernal, more than twenty miles distant, and say, "This is my backyard. Pretty good, isn't it?"

·The Roofless Room·

One Sunday morning in late spring we pre-
pared for our first meal of the season in the
roofless room, a space connected to the house with adobe walls but
open to the elements. Thin aspen poles, called *latíllas,* placed at regular
intervals, spanned the open roof area. Screening kept out birds and
insects. An open window to the garden was also screened and guarded
by a few thin vertical poles. The floor was gravel, and the walls were
white. We washed the table, a sizable slab of pale red flagstone, and
from the dining room we brought two captain's chairs cushioned with
bright Mexican weavings.

Miss O'Keeffe asked, "Wouldn't you like a fine glass of cold beer
with the noon meal?" That meant she would very much like a glass
of good beer. We searched the kitchen and pantry but none was to
be found in the house, and since it was Sunday we couldn't buy any.
I thought of my neighbor Willie, who worked at Ghost Ranch. My
hunch was right, and before long he appeared with two bottles of cold
Mexican beer, quite pleased at the opportunity to provide a simple
pleasure for Georgia O'Keeffe.

I set the stone table with straw mats, soft fringed white napkins, and
glasses for water and beer. The plain white china plates were warming
on top of the Chambers range. Herb salt was served in a tiny white
china sake cup with a miniature mother-of-pearl spoon and pepper in
a small French grinder.

Through the screened window, we looked out on blue and purple iris blooming in abundance, with dark green foliage filling the background. Robins and meadowlarks sang in the towering old mulberry tree. Lilacs were in full blossom along the far wall. Since the sun was directly above, we wore wide-brimmed straw hats. Miss O'Keeffe sat with remarkable posture in her classic white dress with the silver "OK" pin on her lapel. I had brushed her long white hair and circled it on top of her head. She sometimes commented on how much hair came out of her head upon brushing, saying it was a wonder she had any hair left.

We sat eating and talking, sipping our precious beer and feeling the exquisite touch of spring warmth. For the noon meal, I had prepared a tomato soufflé and a salad, a mixture of different lettuces and many herbs. The young parsley was particularly sweet and flavorful. For the tomato soufflé, I had blended sweet garden tomatoes canned the previous year, cheddar cheese, freshly ground cumin seeds, and pepper, then folded in egg whites. Somehow that day the soufflé rose perfectly with a lovely, even texture. Steamed asparagus with a little butter accompanied it.

She said, "I think you should be very proud of this meal."

"Thank you," I said. "I think so, too." I was overcome by an immense feeling of calm and satisfaction. The sensation rose in an unexpected moment of perfection. I had a fleeting thought that if I died in this moment I would feel fulfilled.

I felt truly enriched by my work, but after five years with Miss O'Keeffe I began to feel restless. At twenty-eight, I had other needs—to develop a career and to be near more people. It was difficult to tell Miss O'Keeffe and Juan about my decision. It was painful, as well, to leave the peace and beauty of my little village. Miss O'Keeffe often said, "Isn't it too bad you won't be here to see our lovely fires this winter?" and "Won't you miss the watercress stream?" But I knew I had to find my way in the rest of the world.

Subsequently, I found work with a weaver in Santa Fe, and became a caregiver to a family with elderly parents. I quickly realized that there was no comparison between this older couple and Miss O'Keeffe. I continued to see Miss O'Keeffe on monthly visits. I would call and ask if she wanted to go to the ranch for a picnic. She would say my name in surprise and respond with pleasure as we planned our outing. She was lively and alert at ninety-six, although she occasionally didn't feel hardy enough to go for an outing.

We had several fine times sharing a simple lunch and walking around the Ghost Ranch house. When I would leave her to return to Santa Fe, she would cheerily call out, "Luck to you!"

Late in her ninety-sixth year, Miss O'Keeffe moved with Juan and his family to a large Santa Fe house as their base of operations. Business was easier from Santa Fe, Miss O'Keeffe was closer to caregivers and doctors if they were needed, and Juan's children were near a school.

As the aging artist showed increased fatigue, Juan provided caregivers twenty-four hours a day. I visited her in her first few months in Santa Fe, in the fall of 1984. Our time was familiar and pleasant, although Miss O'Keeffe tired quickly. I recounted some of our funny escapades, which made her laugh, and I described my adventures in graduate school for speech pathology in Albuquerque. She wished me well in my endeavor.

About a year later, in November of 1985, I visited again. By then my life had become full with class work and commuting to Albuquerque. When I called to request a visit with Miss O'Keeffe, Juan warned me that she was beginning to be somewhat forgetful. After her supper Juan walked me into Miss O'Keeffe's room and said, "Georgia, this is Margaret Wood. She worked with you in Abiquiu and Ghost Ranch. You'll remember her."

I began by reminding her about my family. "Miss O'Keeffe, I told you about my mother, who practices the pipe organ at midnight, and my father, who had three wives and several children."

She gave no response and gazed at me politely but without familiarity.

"I'm the weaver who picked plants to dye wool, and you helped me with some of my designs."

"How nice for you," she said.

After a prolonged silence, I tried another subject. "I love to cook. We made sauerkraut from your surplus of cabbage one fall," I offered.

"Did it turn out well?" she asked.

"You especially liked the lemon pecan fruitcake I made. We cut it into thin slices and toasted it." Still she gave no sign of recognition.

I then asked about her family members whom I had met, two sisters and a niece. None of my approaches elicited a link to our shared past. She was tiring, and I knew that this conversation was futile. I politely thanked her for the visit and said good-bye. She remarked that I had certainly learned a lot from her through all my questions.

I sadly described the visit to Juan before I left. I think he also felt disheartened by my tale of the encounter. I was stunned to think that

my cherished friend could forget me. We had shared so much time over the years. How could she forget the things we had done? Was it because I had not kept in frequent contact with her since she moved to Santa Fe, or that she was no longer in the environments we had shared? I was forced to recognize that, as her memory began to fail, I was no longer a familiar person in her world and that after knowing Miss O'Keeffe for more than seven years, there was no reason to visit again.

I felt a searing grief at the loss of her friendship. Her erased recollection made our time together seem like a fragile reality. For months, I wrestled with accepting this haunting truth. As a comfort, Miss O'Keeffe would appear in my dreams now and then, and in them we shared time as we had before.

In the spring of 1986, more than a year after my last visit, Miss O'Keeffe died at the age of ninety-eight. I was still in graduate school, and my housemate told me the news. It was not surprising, but nevertheless I was shocked. It seemed as though she would live forever. The facts reflected an ordinary death, yet with her passing an extraordinary influence in my life had vanished.

I thought about the variety of feelings I had experienced with her, from exasperation to love. I reflected upon her remarkable life. When I thought about her death, I hoped she had died peacefully. I wished she could have died at Ghost Ranch, the place she loved best, gazing toward Pedernal in one direction, the brilliantly colored cliffs in another. In my mind, her regal spirit still reigns over that entire kingdom, from the magical flat-topped mountain to those majestic cliffs.